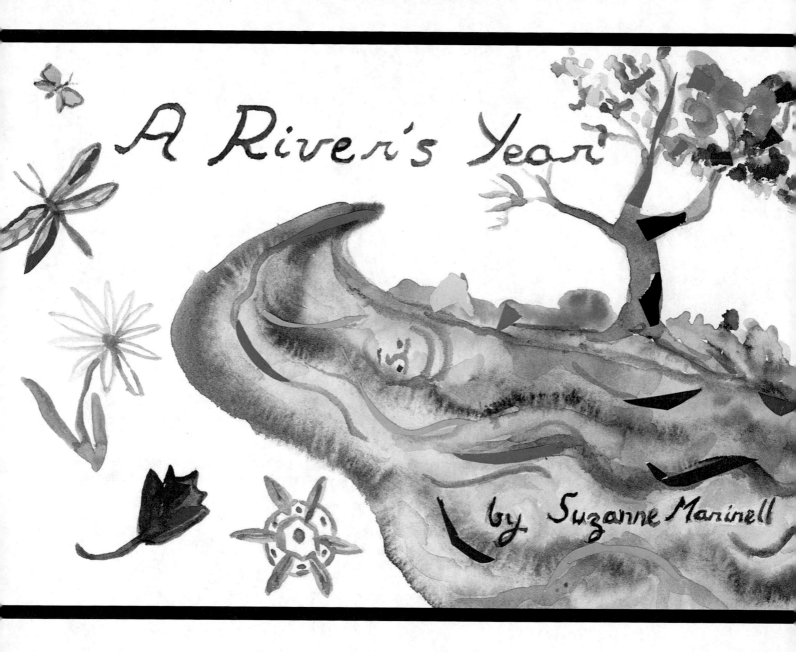

A River's Year

by Suzanne Marinell

written and illustrated by
Suzanne Marinell

To order additional copies of this book, contact:
Xlibris
844-714-8691
www.Xlibris.com
Orders@Xlibris.com

Book Designer: Jerome Cuyos

ISBN: 978-1-4257-0764-4 (sc)

Library of Congress Control Number: 2006900400

Print information available on the last page

Rev. date: 01/25/2024

Dedicated

to all my students,
with thanks for their curiosity and enthusiasm.

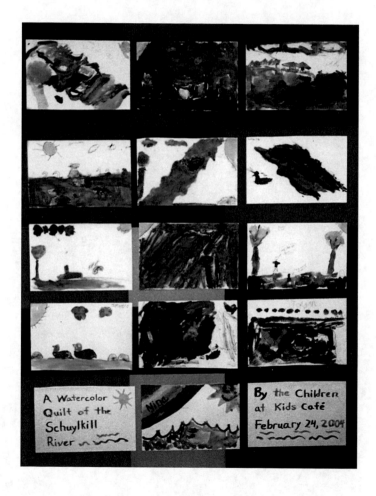

Watercolors done by the children at Kids' Cafe at the George Washington Carver Center,
Norristown, Pennsylvania when learning about the Schuylkill River.

4

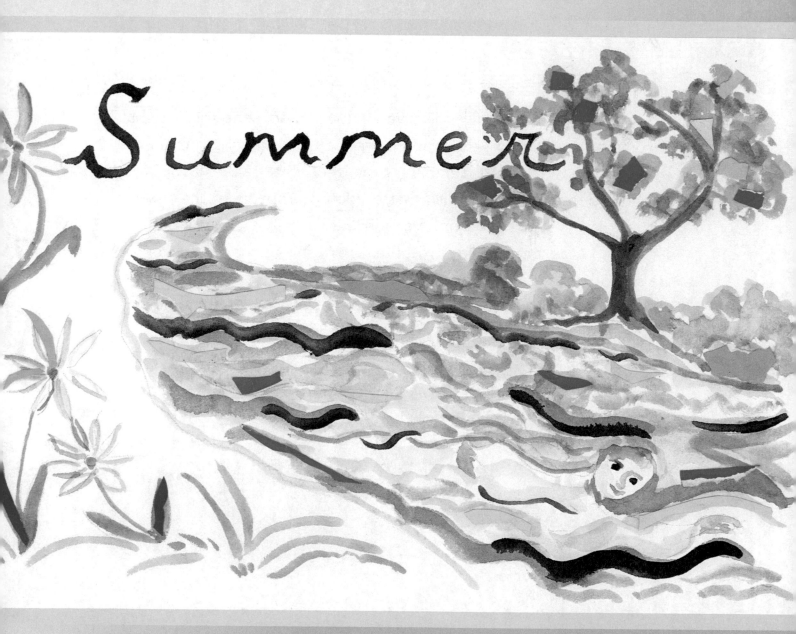

One day they finally discovered me. I had sent them signals of sunlight sparkling on the water's surface. I had laughed my name, Ganschowehanne, as I tumbled over the waterfall. Maybe they recognized me in the silver fish that suddenly jumped in front of them as they played at the edge of Riverfront Park, the girl and the boy. Or, perhaps they saw me smiling up at their friendship as they looked below the smooth water at twilight.

"Ganschowehanne," they called to me. "Take us with you. Show us the river's secrets. Teach us its mysteries."

"I will, I will," I called back. "Come to the river often, every season. Listen and watch. Be quiet when it is quiet. Be joyful when the water rushes by you. Observe the animals that live in and around it. Learn from the wise people who already know the river well. Come now, in the sunlight, or the lazy stillness of summer. I will speak to you often."

The children did come, and learned these things:

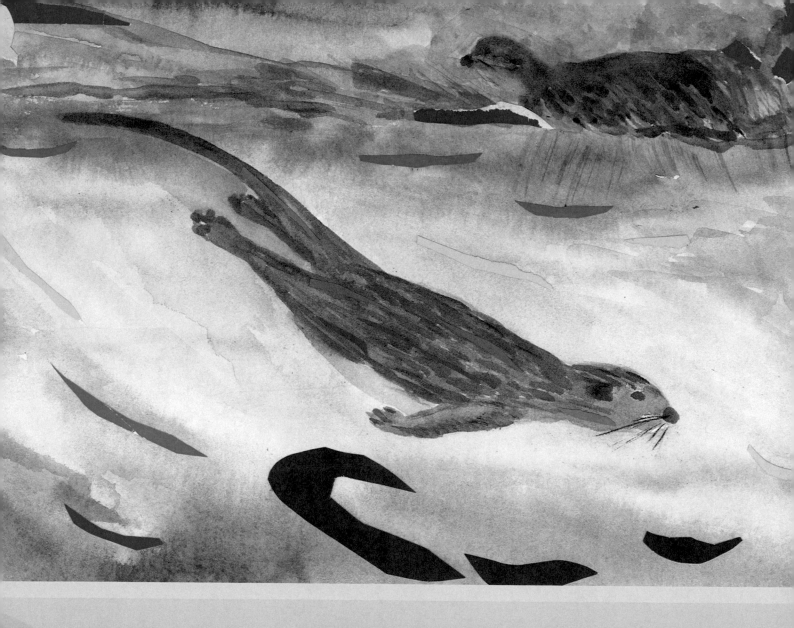

River otters play,
Sleek bodies sliding, swimming
Through sparkles of light.

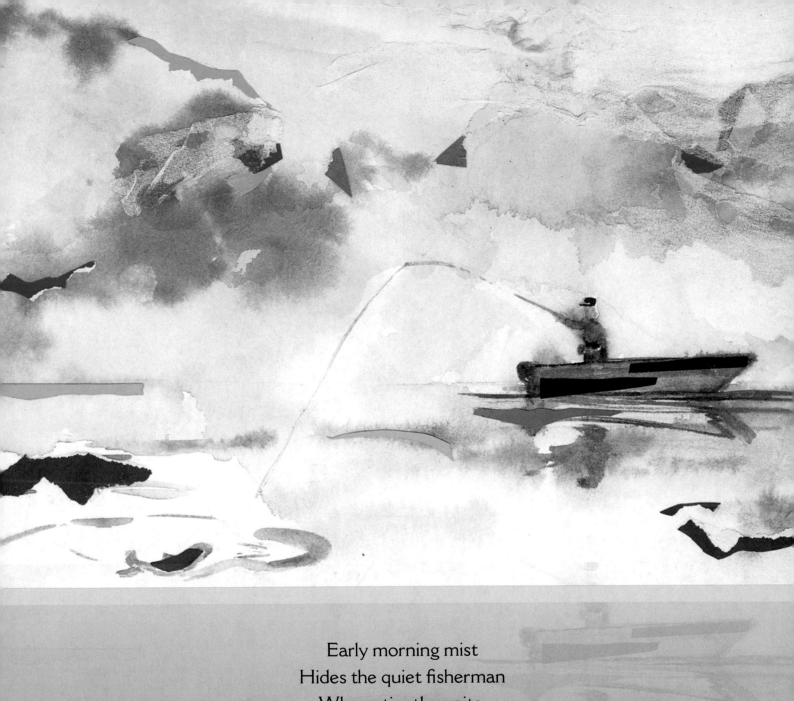

Early morning mist
Hides the quiet fisherman
Who patiently waits.

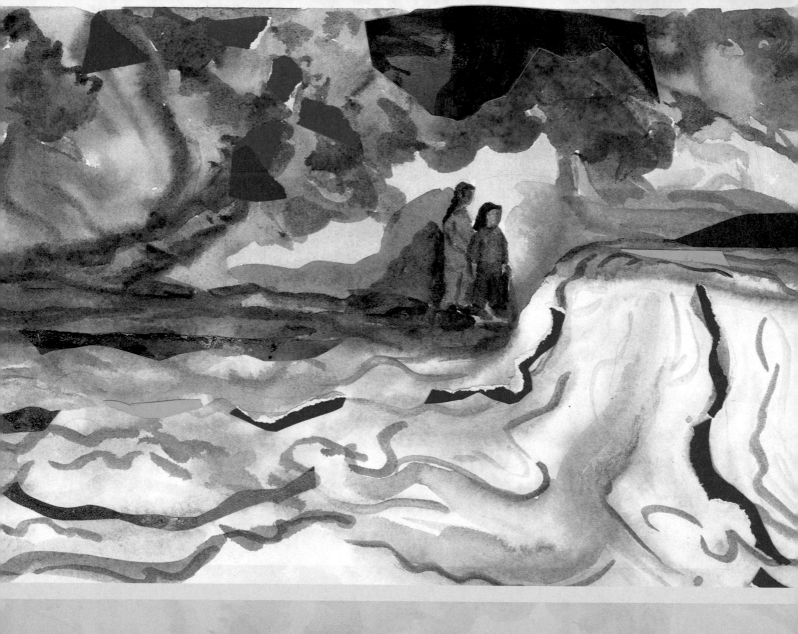

Ganschowehanne-
Stream whose falls, ripples make noise.
Lenapes named you.

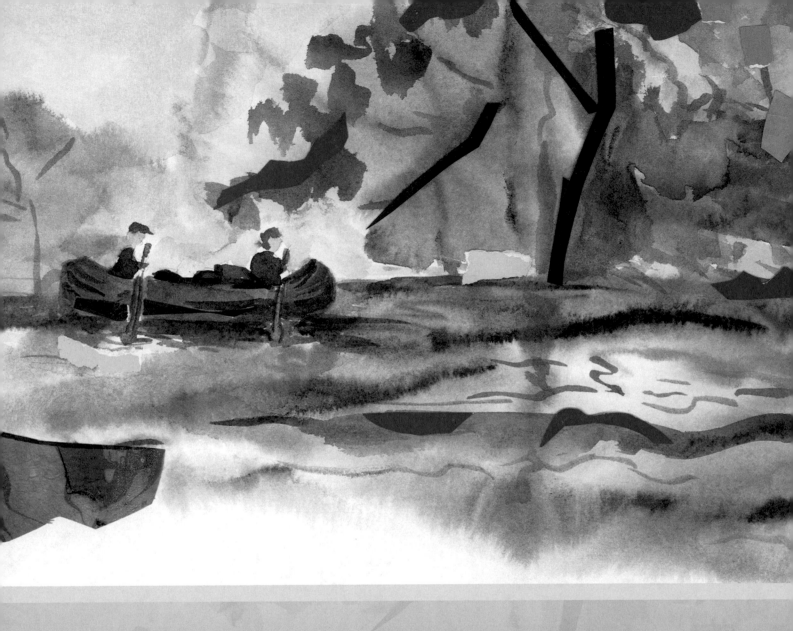

Silent canoes pass.
Long ago they brought furs and fish
Caught by agile hands.

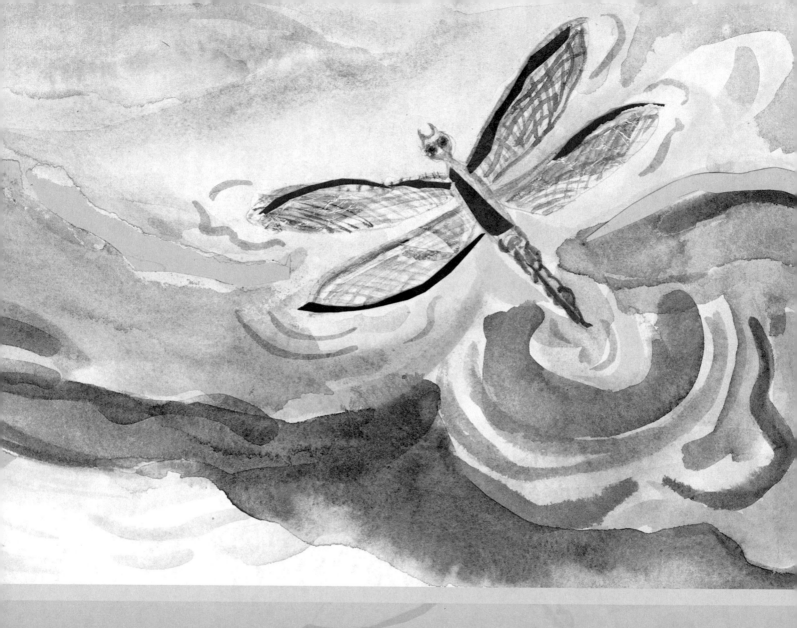

Dragonflies vibrate,
Their iridescence skimming
Water's bright surface.

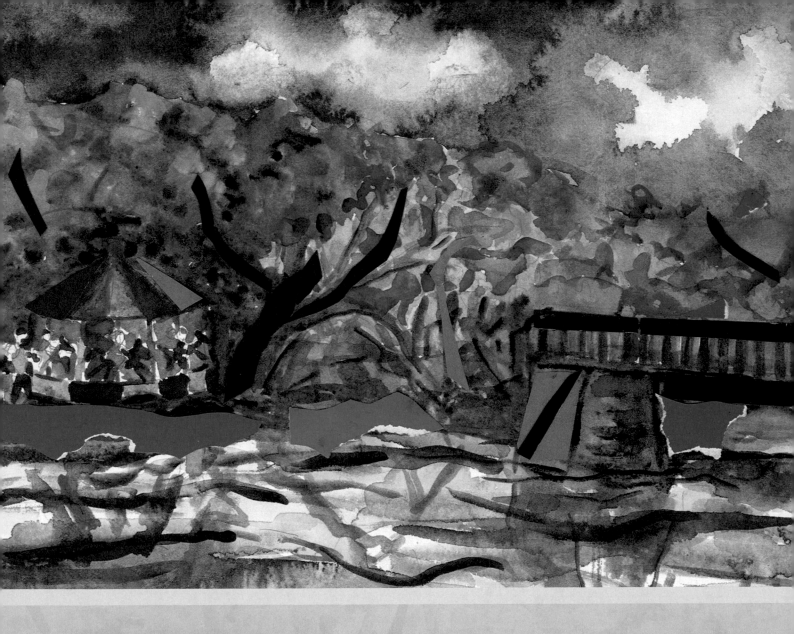

Once on an island
Carousels whirled merrily.
Laughter disappeared.

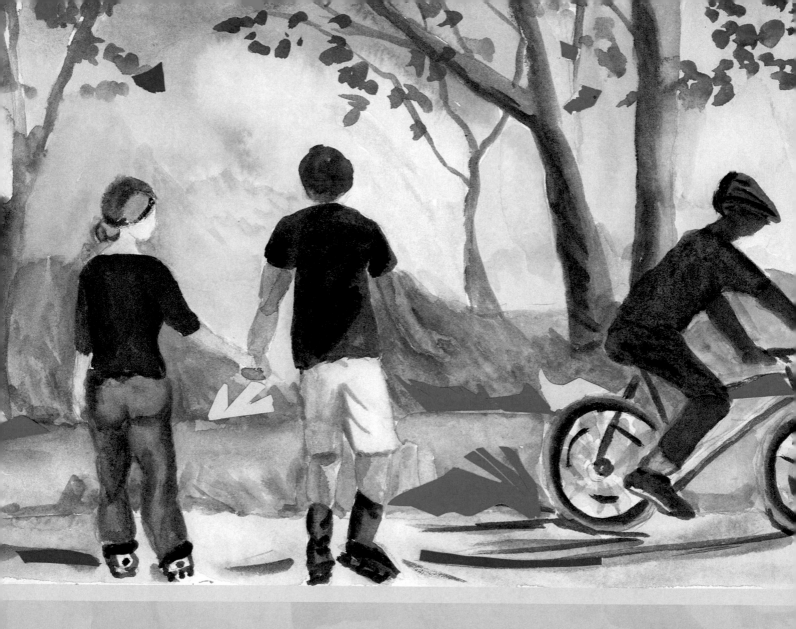

We walk by your banks,
Then run, skate, go biking fast,
Wanting your movement.

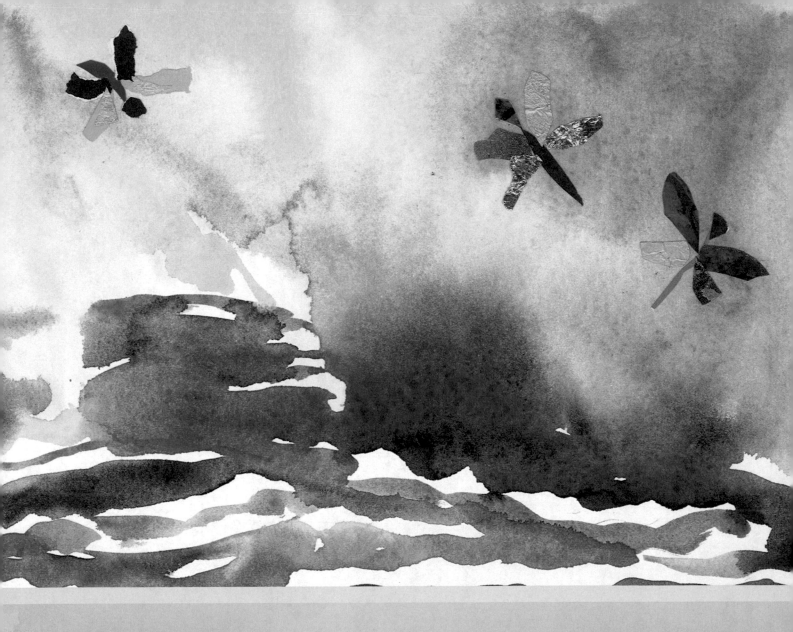

Fresh coolness flowing
Through thick, humid summer heat,
Liquid quenching thirst.

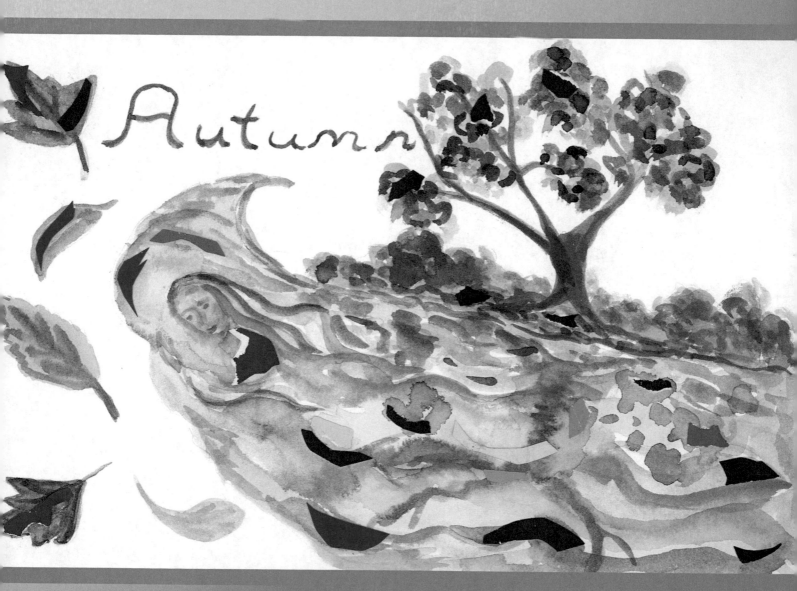

Then summer passed into autumn. The children still came, though the days grew shorter and colder. But the river is beautiful as the air clears and chills and reflects autumn's golds and reds.

"Listen, children," I called to them. "Here are my autumn messages:

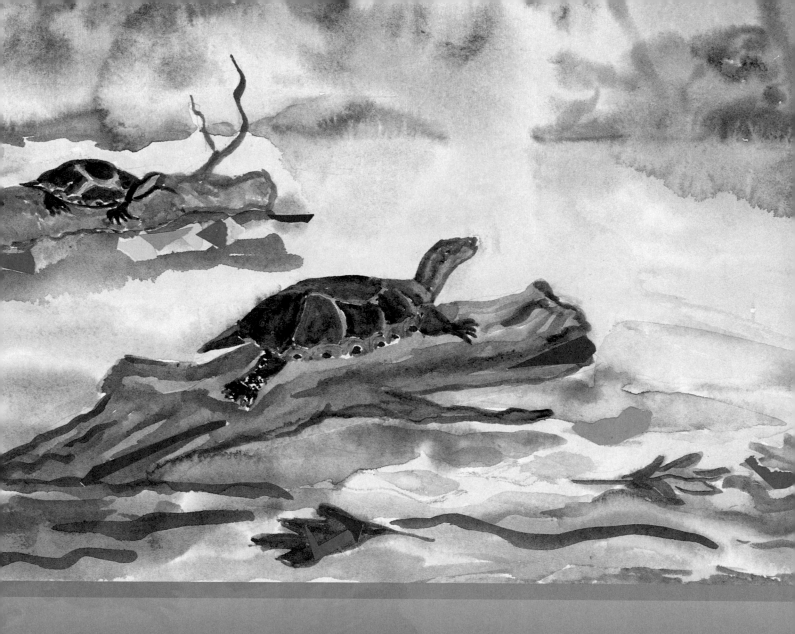

Turtles sit on logs
To savor sun's warmth.
Cooling water chills.

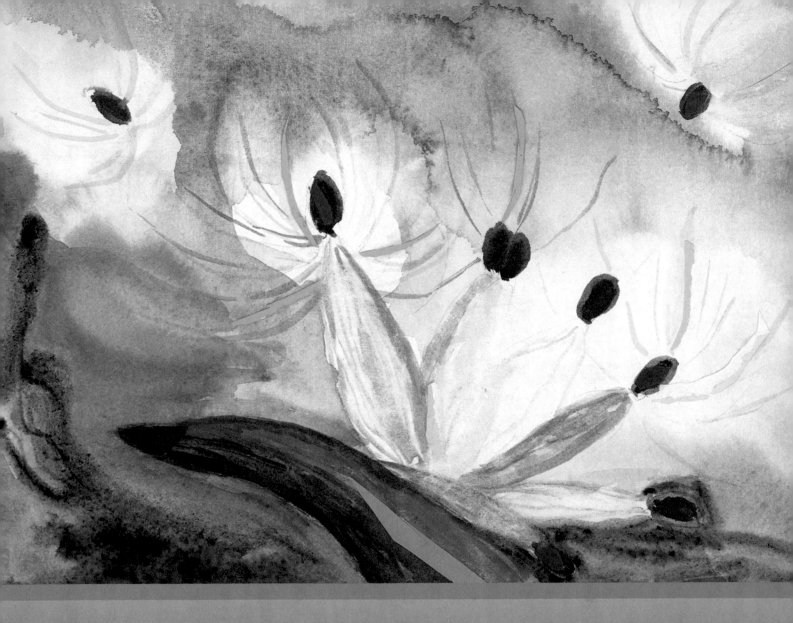

Milkweed seeds float, drift,
Silky threads carried by wind
To land, sleep, then grow.

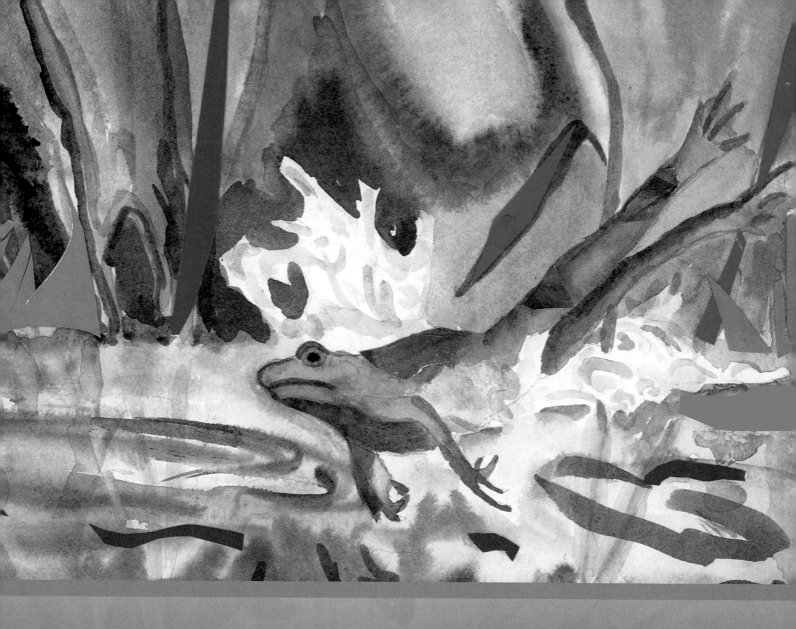

Splash! A small frog jumps,
Swims down to cool mud,
Almost time to sleep.

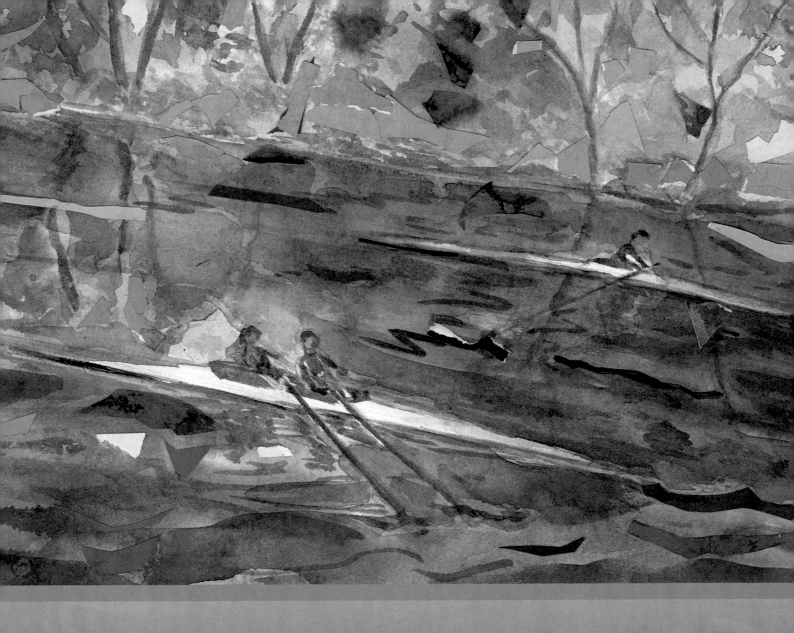

Rowers gather, race,
Testing strength, rhythm, they glide,
Smooth exuberance.

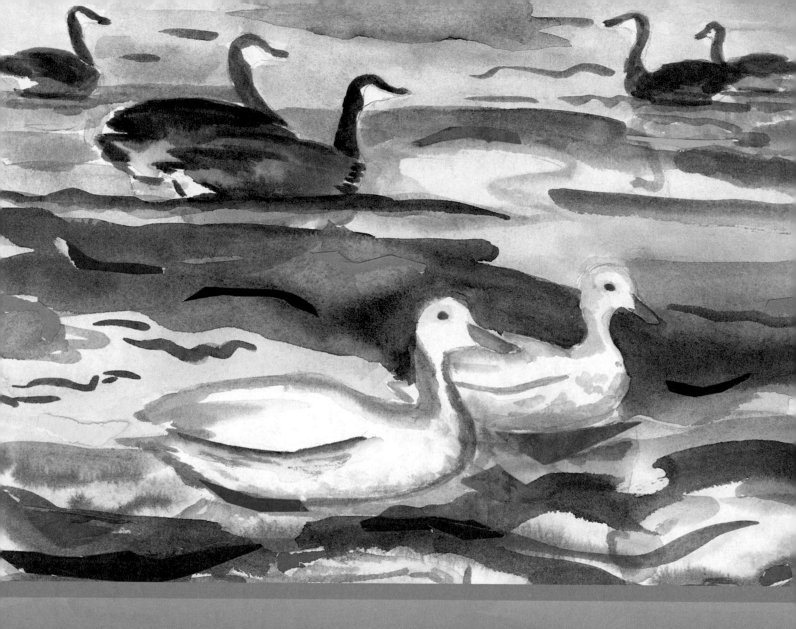

Two white ducks swimming
Together among the geese.
Then one day they are gone.

Orange, red, golden
Leaves still held by trees.
Dark water now glows.

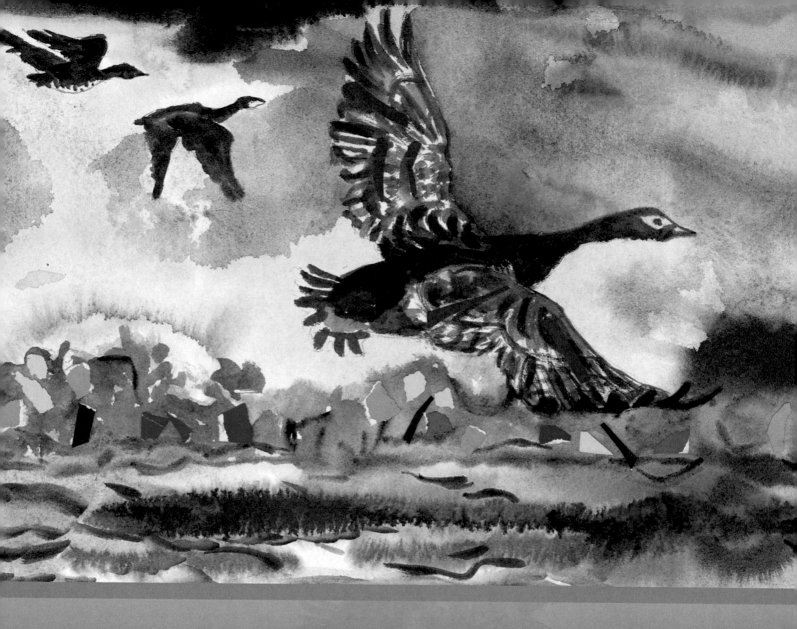

Gathering geese fly
Down to their river home as
The setting sun calls.

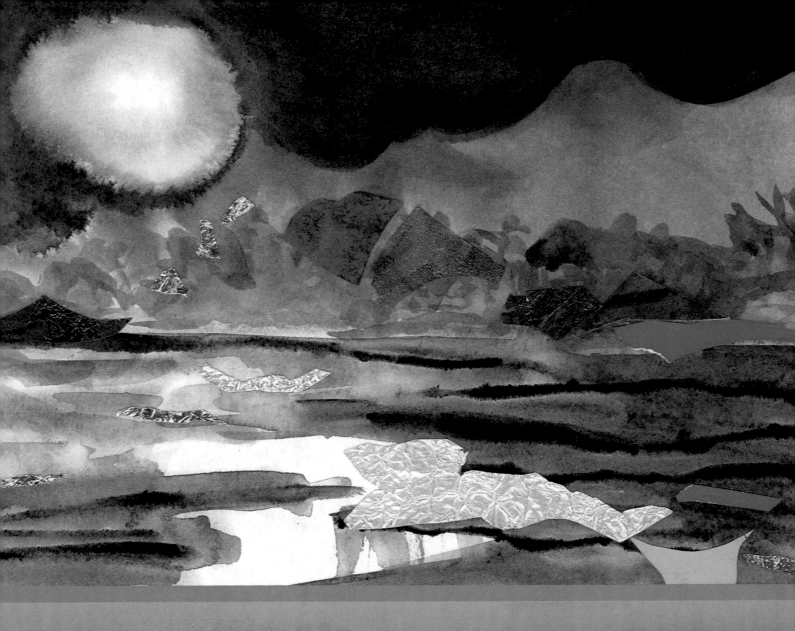

The full harvest moon
Leaves a path, broken silver
Across flowing night.

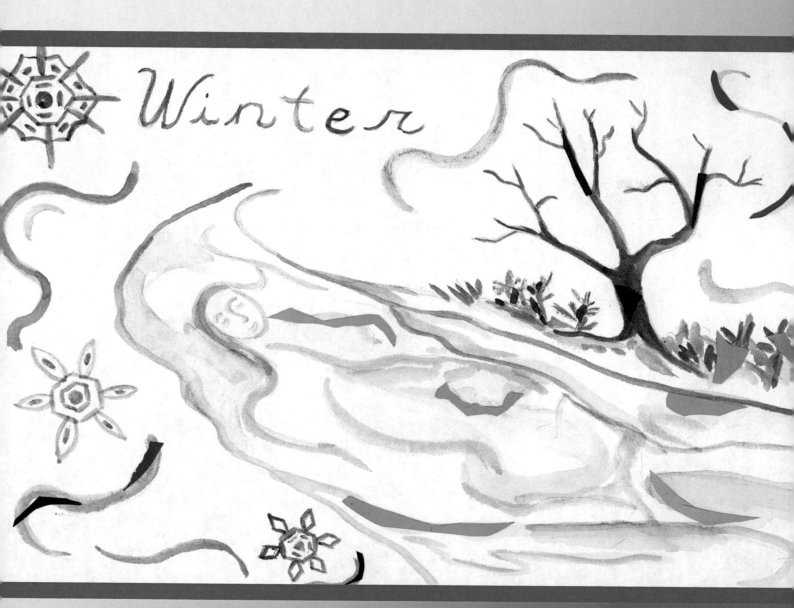

Night, cold, darkness settles in. The days get shorter and shorter as winter arrives. The children come to feed the ducks and the geese, but I don't see them as often. I sleep more, and move slowly. I ponder on my river's future, and on its past. Sometimes, though, when the air is clear and the water brilliant, I swim up to the surface to feel the sun's distant warmth. But I send my winter thoughts and observations to the children in the glittering river's frozen fragments.

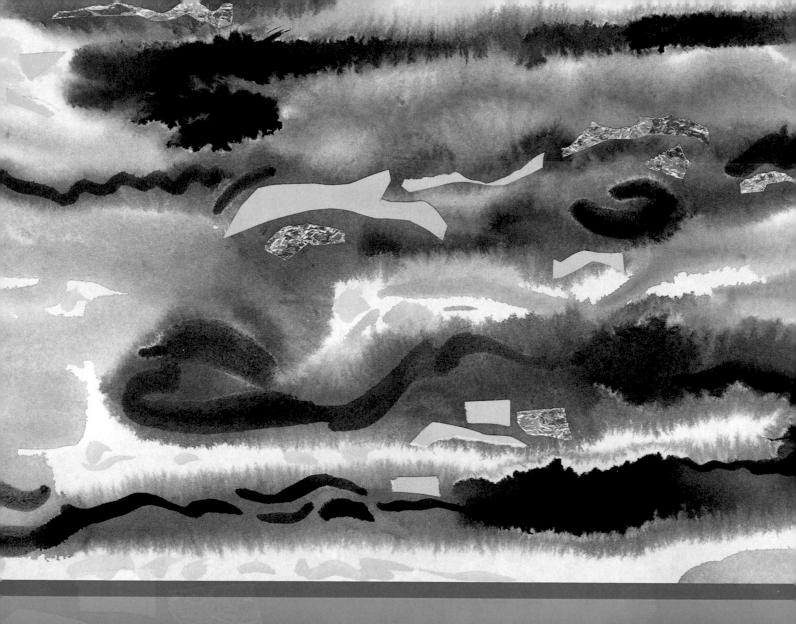

Sunlight's broken shapes-
Crystal slivers of cold glass
Dance across wind's waves.

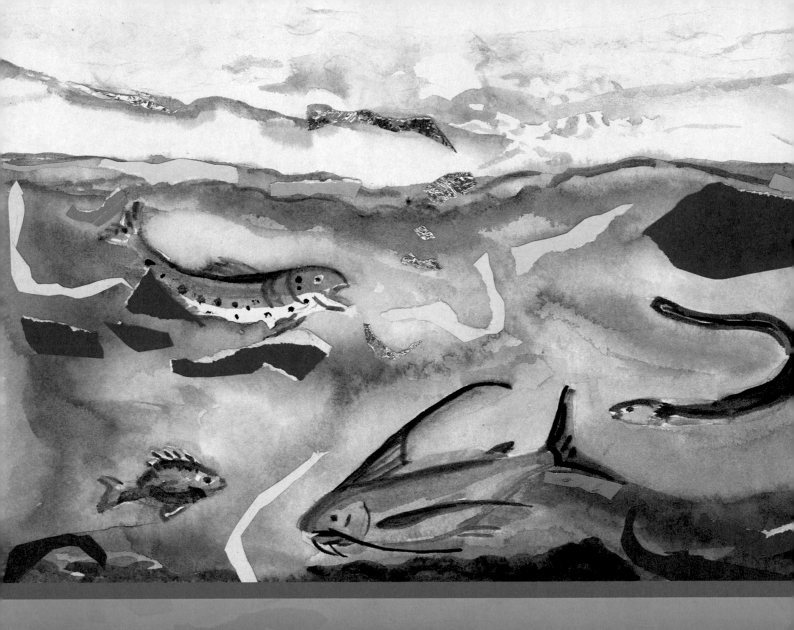

Once blown water,
Frozen waves, captured liquid.
Secrets move below.

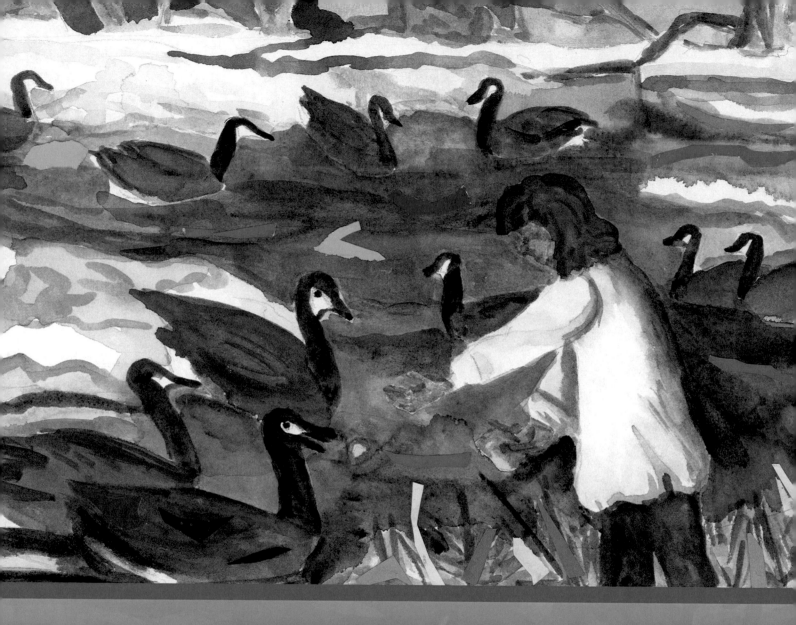

A young girl in white
Reaches across river ice
To feed hungry geese.

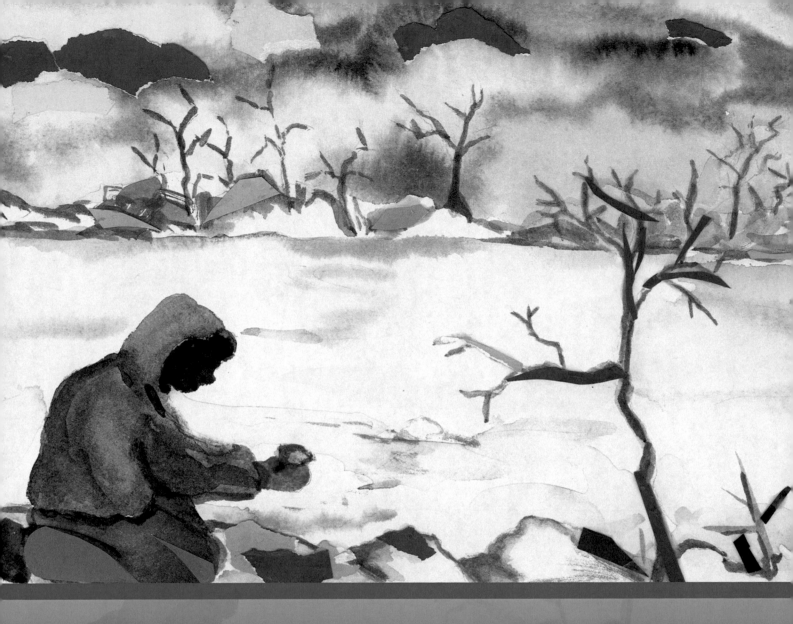

Ice leaves a boy's hand
To whistle and skim across
River's frozen flow.

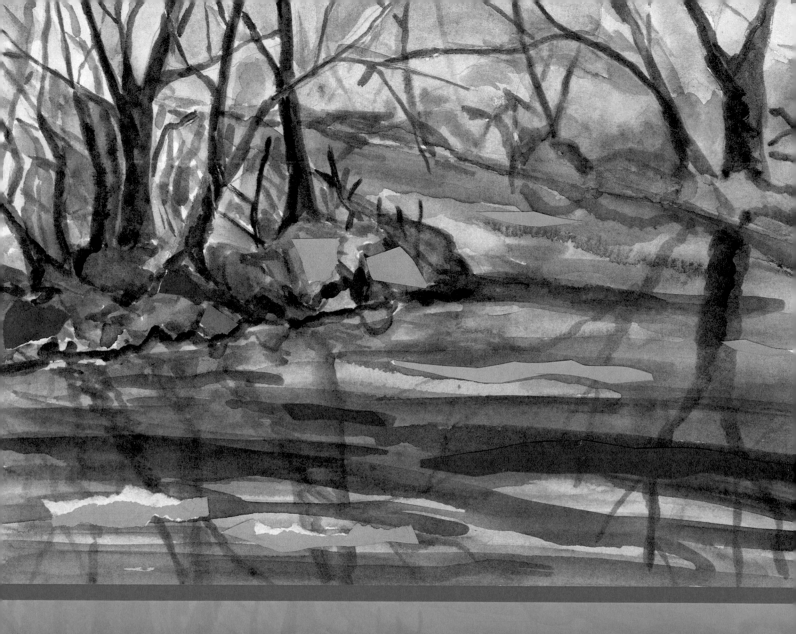

Once graceful lindens
Grew along your curving banks,
Tree bones' arching reach.

Bulrushes, islands
Kept your well disguised entrance
From explorers' eyes.

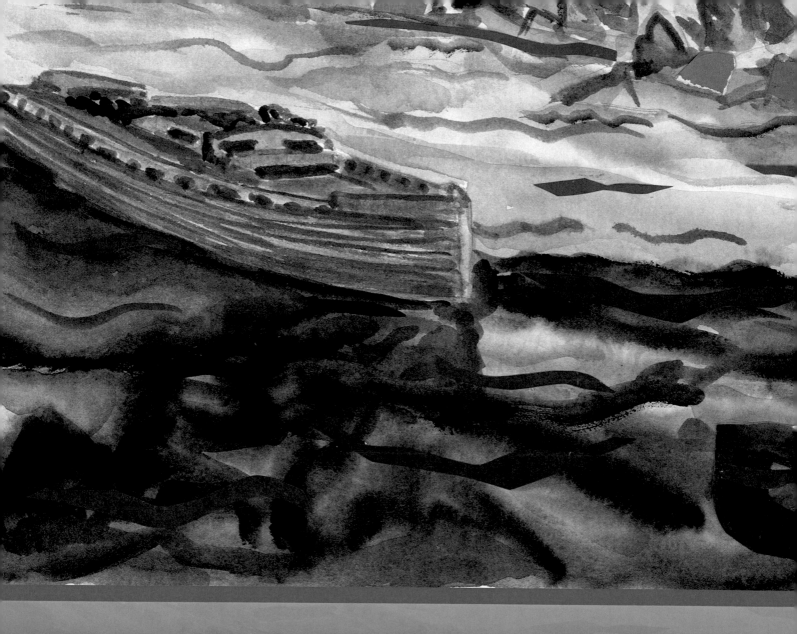

Slow barges brought coal,
Black rocks becoming heat, warmth,
Bringing silt, then death.

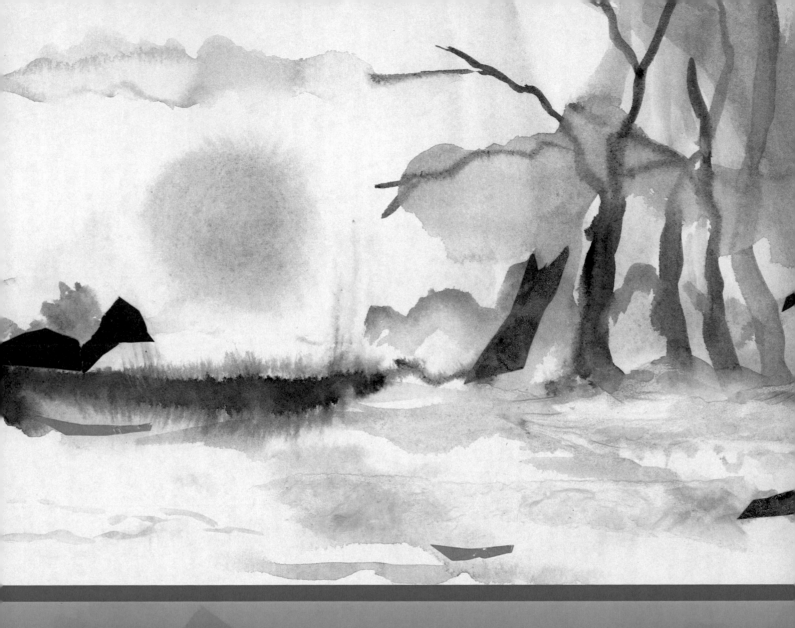

Frozen white water
Reflects sun's soft setting light.
Misty darkness falls.

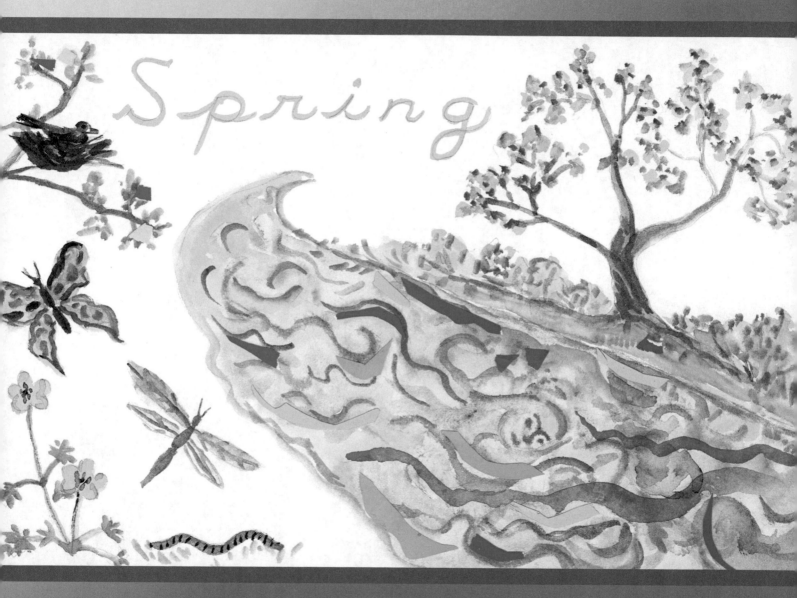

Gradually, the darkness is gentler as the creatures begin to wake up. Their singing begins. I send a song to the children in the cracking ice and the hurrying water. I sing to them of the joyful river in spring.

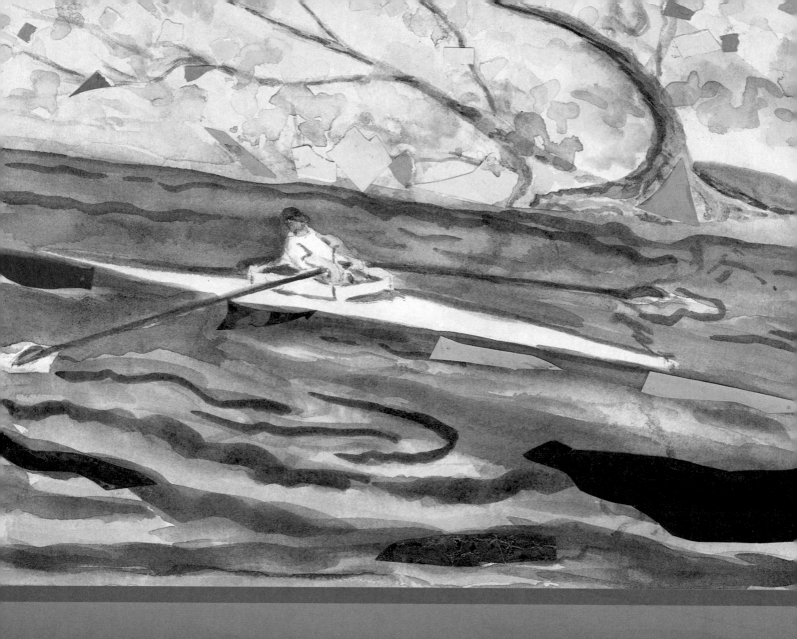

Water thaws early.
Sunlight warms awakening
Breeze to hurry oars.

Circles move outward.
A quiet path of motion.
Oars repeat the stroke.

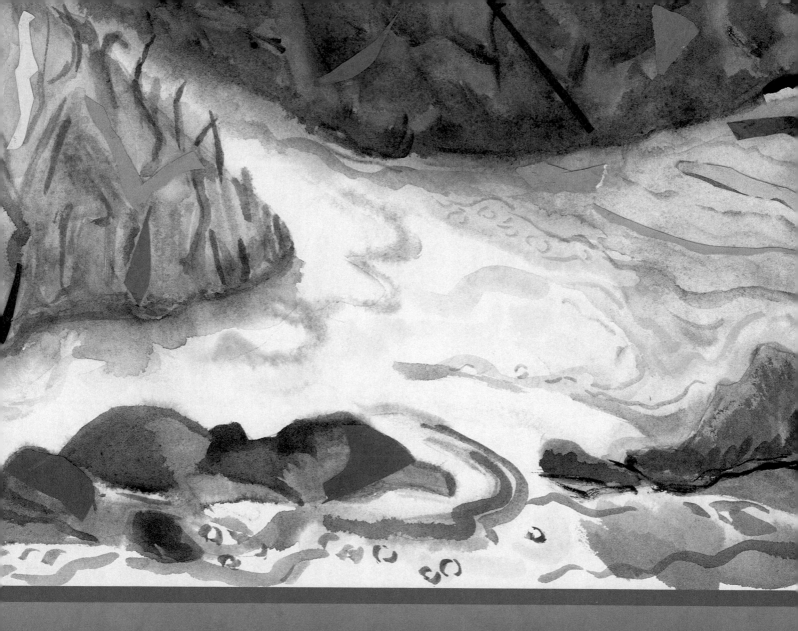

Melted snow and ice
Bubble through your veins-
Rejuvenate life.

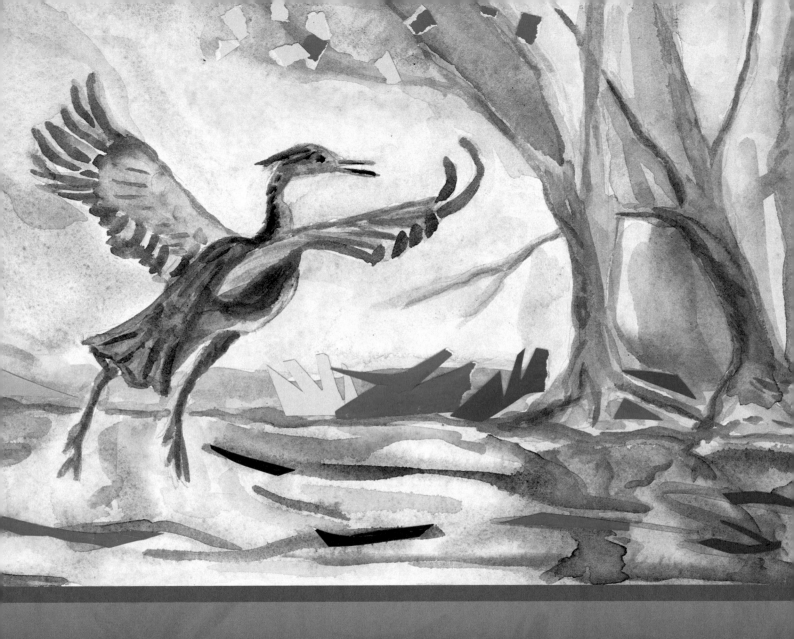

The great blue heron
Silently crosses our bow
To vanish in trees.

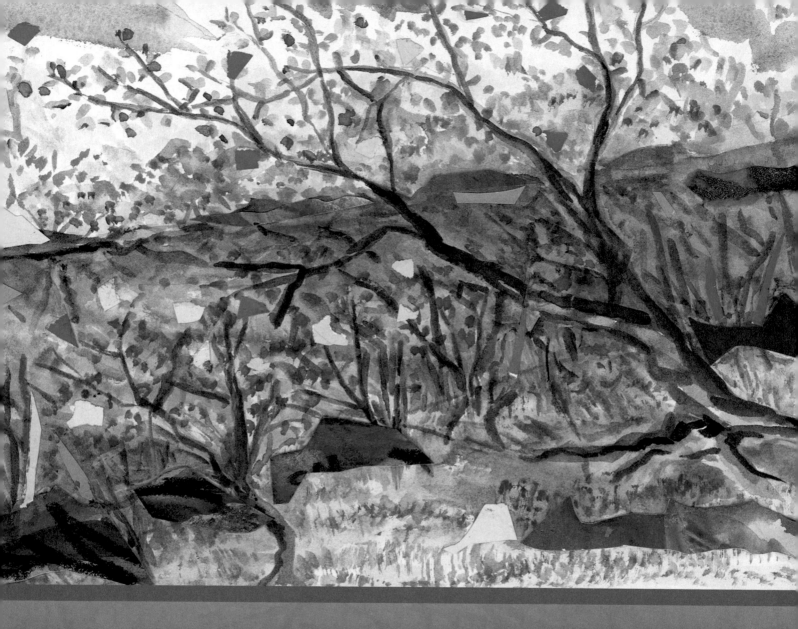

Trees' fingers hold tight
Golden green opening buds.
Soon they will bring shade.

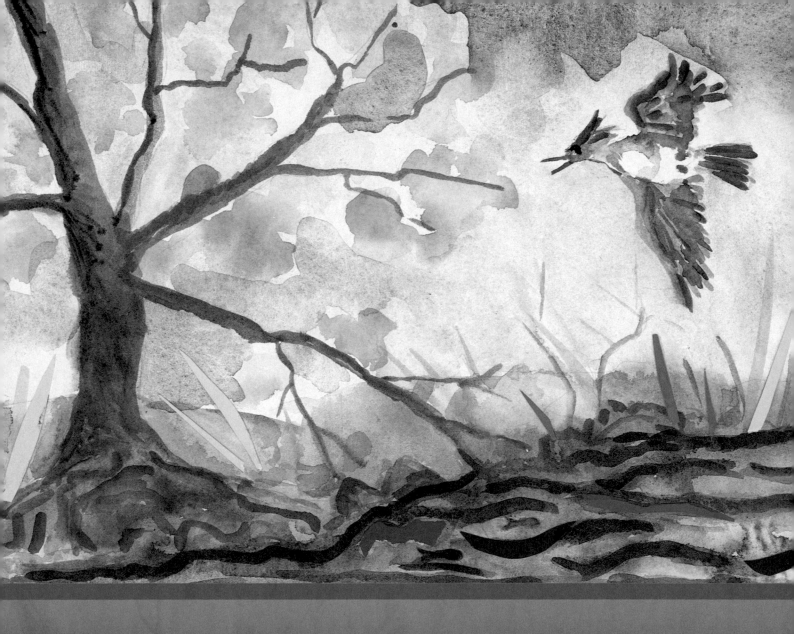

A kingfisher darts
Into a tree that bends low
Over hidden prey.

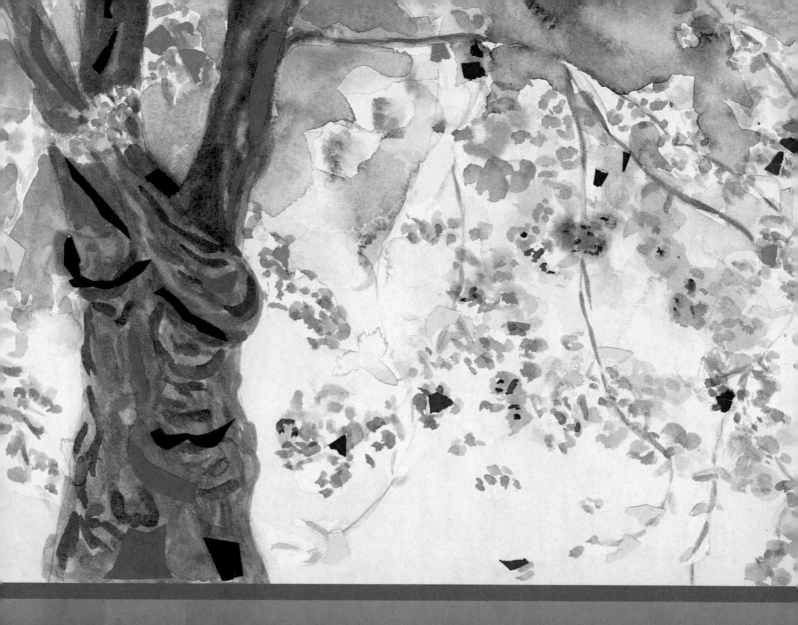

Pale pink blossoms blow
Gently on weeping branches.
A gift from the East.

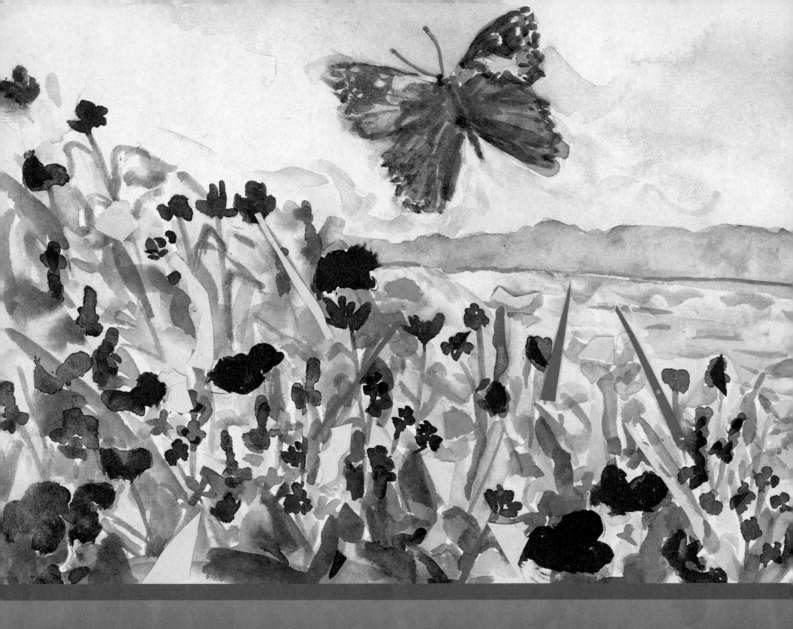

A painted lady
Flits among wildflowers
Tasting spring's sweetness.

The River

While the poems in A River's Year could be about any river, they were inspired by the Schuylkill River in Pennsylvania. The Schuylkill originates from two small streams in Broad Mountain, Rush Township, Schuylkill County, PA. It flows southeast for about 125 miles.

In the 1650s, there was a lot of beaver trade with the Lenape Indians, who traveled the river in their canoes. It is uncertain as to who were the Schuylkill's first European explorers. One theory is that Dutch Captain Hendrickson, who explored the area in 1616, discovered the river and named it Schuylkill, which means "hidden river" in Dutch, because the mouth was hidden by several low islands. There was another sailor, Arendt Corssen, who might also have named it, claiming that its entrance was hidden by bulrushes. The river also had several Indian names. On one map, it is named Mittabakonck. The "-onk" signifies "at the island." Mittabakonck could also be a corruption of Mene-iunk, which means "where we go to drink." Apparently when William Penn made purchases in 1683 and 1685, the river was called Manaiunk. The river is supposed to have reminded Penn of the Thames that flows through London, and he explored the Schuylkill in a canoe during his second trip to Pennsylvania. Today, a section of Philadelphia along the river is called Manayunk. A missionary named John Heckewelder wrote that the Indians also called the river Ganschowehanne, meaning "a stream whose falls and ripples make noise." And, before Penn, in 1655, the Swedes called the river Linde Kilen, which means linden stream, as there were many large linden trees growing along the banks.

Throughout the years, there has been peace, prosperity, controversy, and hard times for the Schuylkill. We know that the Lenapes found many fish and beavers. In 1683, when white settlers were now in the area using the river, an act was passed so that dams couldn't be built, as they would hinder navigation and fish breeding. There was another act passed in 1700 to this effect, and apparently in the 1730s, there were many arguments as to whether or not dams could be built. The shore men wanted the dams, as they were good places to catch fish. The navigators were against them, as sometimes when they were going down the river in their canoes with loads of wheat, they would hit the dams and lose their cargo. Timber and bricks were also taken down the river. There were actual riots and stone throwing battles between the two groups until the Honorable James Logan, President of Council in Philadelphia, issued a warrant in 1738 for the arrest of the rioters, which seemed to end the conflict. At this time, fish were abundant, including shad, herring, and rockfish, and sturgeon would swim up from the Atlantic Ocean every spring.

The discovery of anthracite coal at the Schuylkill's headwaters drastically changed the life of the river. In 1829, 200 boats would go up and down the river every week, most of them carrying coal. The dams and the canal that was built stopped the ascent of the fish, and as industry grew, the river became more and more polluted. By the 1950s, there were only eels and catfish left in the river. Fortunately, as the result of much clean up work, by the 1990s there was a dramatic turn around for the river. There are now over 40 varieties of fish in the Schuylkill, as well as blue crabs, great blue herons, cormorants, and many other river creatures. With continued care and awareness, this lovely river should continue to prosper and bring to those who come to it the joy of many kinds of recreation, fresh water and food, and knowledge of the natural world.

Sources:

1. <u>History of Montgomery County, Pennsylvania</u>, Bean, vol. 1, 1884, p. 118, chapter IX, "The Schuylkill"

2. <u>Indian Villages and Place Names in Pennsylvania</u>, Dr. George P. Donehoo, Telegraph Press, Harrisburg, PA, 1928.

3. <u>A Brief History of Montgomery County</u>, H. W. Kriebel, The School Directors' Assocation, Norristown, PA, 1923.

4. <u>The Schuylkill</u>, J. Bennett Nolan, Rutgers University Press, New Brunswick, NJ, 1951.

Activities for "A River's Year"

1. Find something in one of the illustrations that you especially like, and write your own haiku about it. A haiku is a Japanese form of poetry that often has the form of the first line with five syllables, the second line with seven syllables, and the third line with five syllables. It attempts to capture a moment in time and nature.

2. Go to a river near you every season.

3. Find an animal each time and draw it or paint it (from a distance). Try adding collage to a picture.

4. Skim a piece of ice across some frozen water. (Go with an adult and don't try to walk on the ice!). Describe the sound it makes.

5. Listen to animals in spring time. How many songs do you hear?

6. Find some insects on or near water. Then invent your own insect using clay or everyday materials such as paper towel rolls, tissue paper, and pipe cleaners.

7. Go to your local government office and find out where your drinking water comes from. Visit a treatment plant.

8. Find out the history of a local river.

Printed in the United States
by Baker & Taylor Publisher Services